ARKANA

D1810605

ACCEPT THIS GIFT

Frances Vaughan, PhD, is a psychologist and author, president of the Association for Humanistic Psychology and on the clinical faculty at the University of California. She is the author of *Awakening Intuition* and *The Inward Arc: Healing and Wholeness in Psychotherapy and Spirituality*, and co-editor with Roger Walsh of *Beyond Ego: Transpersonal Dimensions in Psychology*.

Roger Walsh, MD, PhD, is on the faculty of the Department of Psychiatry and Human Behavior of the California College of Medicine and the School of Social Sciences at the University of California. He is co-editor of *Beyond Health and Normality: Explorations of Exceptional Psychological Well-Being* and of *Meditation: Ancient and Contemporary Perspectives*. He is also author of *Staying Alive: The Psychology of Human Survival*, which discusses the psychological causes, costs and potential cures of current global crises. His work has received twenty national and international awards.

Jane English's photographs have been published in translations of two of the Chinese Taoist classics, *Tao Te Ching*, by Lao Tsu, and *Inner Chapters*, by Chuang Tsu.

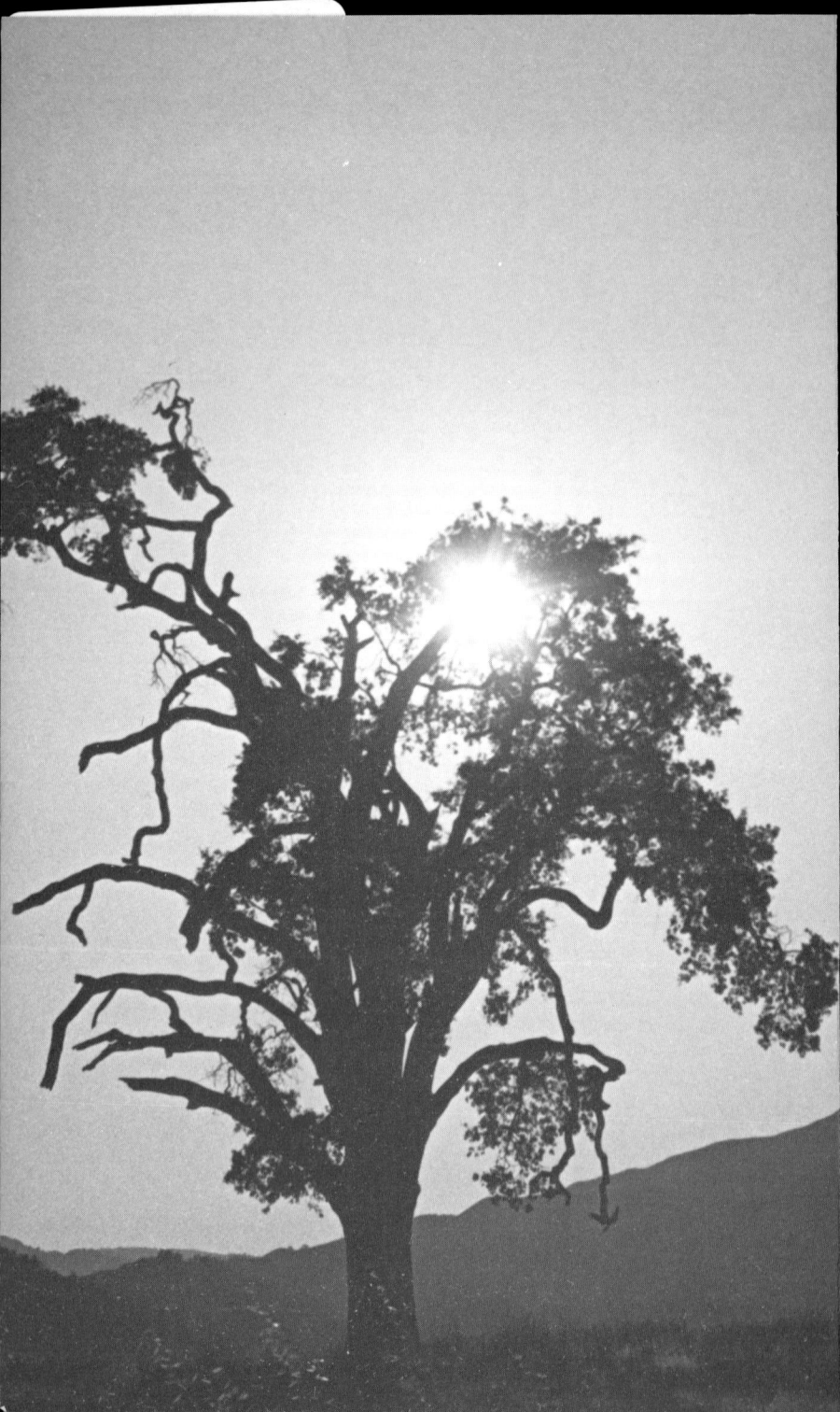

EDITED BY
FRANCES VAUGHAN, PhD, AND
ROGER WALSH, MD, PhD

ACCEPT THIS GIFT

SELECTIONS FROM
A COURSE IN MIRACLES

PHOTOGRAPHS BY JANE ENGLISH, PhD

ARKANA

LONDON

Dedicated to William Thetford
"Love is the way we walk in gratitude."

First published 1988
by ARKANA PAPERBACKS
ARKANA PAPERBACKS is an imprint of
Routledge
11 New Fetter Lane, London EC4P 4EE

Printed in Great Britain
by T.J. Press (Padstow) Ltd,
Padstow, Cornwall.

British Library Cataloguing in Publication data
[A Course in miracles. Selections]. Accept
 this gift : selections from A Course in
 miracles.
 1. Christian life
 I. Vaughan, Frances II. Walsh, Roger
248.4 BV4501.2

ISBN 1-85063-094-1

CONTENTS

Introduction 7

1 The Path of Light 11

 The Nature of the Course *12*
 Miracles *13*
 Purpose *14*
 Choice *16*
 Truth and Reality *18*

2 The Mind 21

 Mind *22*
 Belief *25*
 Thought *26*
 Perception *28*

3 Dreams and Illusions 31

 Dreams *32*
 Illusions *34*

4 The World and Time 37

 The World *38*
 Time *40*

5 Mistaken Identity 43

 Body *44*
 Ego *46*
 Self-Concept *48*

6 True Identity 51

 Identity 52
 Self 54
 Spirit 55

7 Obstacles on the Path 57

 Pain 58
 Guilt 60
 Fear 61
 Anger and Attack 63
 Judgment 65
 Defensiveness 68

8 Healing Relationships 71

 Practicing Forgiveness 72
 Teaching and Learning 76
 Recognizing Your Brother 78
 Healing and Wholeness 80
 The Holy Relationship 82

9 The Peaceful Alternative 85

 Coming Home 86
 Freedom 87
 Salvation 88
 Love 90
 Awakening to God 92
 The Conditions of Peace 94
 Light and Joy 98

10 A New Beginning 101

 References 105

INTRODUCTION

In the search for understanding and awakening we are drawn to those teachings that convey the deepest wisdom with the greatest beauty. When we are fortunate enough to find such a teaching, we may also find limits to our capacity to appreciate it, particularly when profound ideas follow one another as rapidly as they do in *A Course in Miracles*. In studying the *Course*, we have therefore found it helpful to separate out specific passages in order to ponder them more fully. This book is a collection of some of our favorites.

Although written in Christian language and style, *A Course in Miracles* clearly embodies the perennial wisdom found at the core of all the world's great religions. Because of this universal nature, its significance and appeal transcend traditional boundaries and extend to all who seek answers to the deepest questions of human existence. Some Buddhists have said that the *Course* echoes the words of the Buddha; yogis have remarked that it expresses the wisdom of Vedanta; and psychologists have found that it offers insights comparable to some of the best contemporary thinking about phenomena such as perception, belief, and identity.

The *Course* was written down by two psychologists, doctors Helen Schucman and William Thetford, who were both on the faculty of Columbia University College of Physicians and Surgeons. Beginning in 1965, Helen had a series of symbolic dreams and imagery experiences that culminated in hearing an inner Voice that began dictating the *Course*. She was both a psychologist and educator, conservative in theory and atheistic in belief, and was surprised and disconcerted by these events. Since she felt she was the scribe, not the author of this material, she therefore chose to remain anonymous. In her own words Helen said:

> Three startling months preceded the actual writing. . . .
> Although I had grown more accustomed to the unexpected

by that time, I was still very surprised when I wrote, "This is A Course in Miracles. . . ." That was my introduction to the Voice. It made no sound, but seemed to be giving me a kind of rapid, inner dictation which I took down in a shorthand notebook. The writing was never automatic. It could be interrupted at any time and later picked up again. It made me very uncomfortable, but it never seriously occurred to me to stop. It seemed to be a special assignment I had somehow, somewhere agreed to complete. It represented a truly collaborative venture between my friend [William Thetford] and myself, and much of its significance, I am sure, lies in that. . . . The whole process took about six years.

The *Course* was first published in 1976 and consists of three volumes. The first is a text that lays out the underlying thought system; the second a workbook with 365 lessons, one for each day of the year; and the third a teacher's manual designed to clarify terms and facilitate the teaching-learning process.

The language of the *Course* is traditional in its use of Christian terminology and masculine pronouns. Some non-Christians have therefore found that it can be more easily understood when terms such as "salvation" and "Son of God" are translated, for example, as "enlightenment" and "Child of God." The teaching makes no gender distinctions, since in the realm of Spirit, gender is transcended and the form of the language need not obscure the essence of the communication.

The language of the *Course* is exceptionally poetic and contains a wealth of succinct, powerful, and moving aphorisms that readily stand by themselves as potent capsules of wisdom. For those who have already studied the material, such quotes may provide fresh opportunities to appreciate it and offer easy access to ideas on specific subjects. For those unfamiliar with the *Course*, these quotations may stimulate interest in exploring the original source.

Certainly a full appreciation of the *Course* demands studying the original material, whose extraordinary richness, profundity, and integrated thought system cannot possibly be represented in brief extracts. In the *Course*, thoughts build on and interconnect with one another in a mutually supportive network of ideas that create a symphonic whole of which no extract, no matter how beautiful and succinct, can express more than a partial and selective perspective. The parts cannot

substitute for the whole any more than a few melodies can substitute for a symphony. The full power and impact of the *Course* can only be appreciated by studying it directly. If this book encourages readers to do so, it will have served its purpose well.

We have been studying the *Course* for several years, and our appreciation for it continues to grow. As with all profound teachings, deeper and deeper levels may be recognized as one continues to work with it. We were moved to prepare this book of aphorisms when we realized just how impactful such brief quotations could be. From among our favorites we have selected some that we consider succinct, profound, and poetic, and capable of being understood without previous familiarity with the *Course* itself.

This volume can best be read and reread slowly and reflectively, allowing time to appreciate the feelings it evokes. Responses to the material tend to vary with different moods and circumstances. What seems difficult at one time may seem obvious at another; what feels healing at times of stress or transition may be a source of joy and delight in quiet moments of contemplation. Some people find it instructive to turn to the material with particular questions in mind, for example, "What is important for me to learn?" "How can I improve my relationships?" "What should I remember today?" "How can I learn to love more fully?" Simply holding a question in mind and opening the book at random can be surprisingly helpful.

The *Course*, therefore, is not only intellectually sophisticated but also eminently practical. To facilitate its practical application, many of the lessons contain affirmations. These are "I" statements that, if repeated often to oneself, can change thinking and behavior in desired directions. Affirmations have been included at the end of most sections and are printed in italics.

A Course in Miracles has been deeply meaningful to us, and we are grateful to the Foundation for Inner Peace for allowing us to share it in this way. We hope that these selections will prove as helpful to you as they have to us, and that they will contribute to the extension of peace in the world.

1
THE PATH OF LIGHT

The Nature of the Course
Miracles
Purpose
Choice
Truth and Reality

Enlightenment is but a recognition,
not a change at all.

A Course in Miracles *offers us a path of awakening. Like all such paths, the* Course *suggests that our usual perception, awareness, and sense of identity are clouded and distorted. It therefore offers us a means of correcting these distortions so that we may see ourselves and the world more clearly. This transformation of perception is what the* Course *means by a "miracle."*

The Nature of the Course

This course was sent
to open up the path of light to us,
and teach us, step by step,
how to return to the eternal Self
we thought we lost.

The goal of the curriculum,
regardless of the teacher you choose,
is "Know thyself."

This is a course in mind training.

To learn this course requires willingness
to question every value that you hold.

The course does not aim at teaching
the meaning of love,
for that is beyond what can be taught.
It does aim, however, at removing the blocks
to the awareness of love's presence,
which is your natural inheritance.

Your goal is to find out who you are.

Miracles

Miracles are natural.
When they do not occur,
something has gone wrong.

Miracles are merely the translation
of denial into truth.

Miracles occur naturally as expressions of love.
The real miracle is the love that inspires them.
In this sense everything that comes from love
is a miracle.

The miracle comes quietly into the mind
that stops an instant and is still.

The miracle of life is ageless
born in time but nourished in eternity.

*I offer only miracles today,
for I would have them be returned to me.*

Purpose

In any situation in which you are uncertain,
the first thing to consider, very simply, is
"What do I want to come of this?
What is it *for*?"
The clarification of the goal belongs at the beginning,
for it is this which will determine the outcome.

Doubt is the result of conflicting wishes.
Be sure of what you want,
and doubt becomes impossible.

Nothing is difficult that is *wholly* desired.

No one who has a single purpose,
unified and sure,
can be afraid.
No one who shares his purpose with him
can *not* be one with him.

It is this one intent we seek today,
uniting our desires with the need of every heart,
the call of every mind,
the hope that lies beyond despair,
the love attack would hide,
the brotherhood that hate has sought to sever,
but which still remains as God created it.

The peace of God is my one goal; the aim
Of all my living here, the end I seek,
My purpose and my function and my life,
While I abide where I am not at home.

Choice

Deceive yourself no longer that you are helpless
in the face of what is done to you.
Acknowledge but that you have been mistaken,
and all effects of your mistakes will disappear.

If you choose to see yourself as unloving
you will not be happy.
You are condemning yourself
and must therefore regard yourself as inadequate.

Trials are but lessons that you failed to learn
presented once again,
so where you made a faulty choice before
you now can make a better one,
and thus escape all pain
that what you chose before
has brought to you.

It is still up to you to choose
to join with truth or with illusion.
But remember that to choose one
is to let the other go.

Pain is illusion;
joy, reality.
Pain is but sleep;
joy is awakening.
Pain is deception;
joy alone is truth.
And so again we make
the only choice that ever can be made;
we choose between illusions and the truth,
or pain and joy,
or hell and Heaven.

I am *responsible for what I see.*
I choose the feelings I experience,
and I decide upon the goal I would achieve.
And everything that seems to happen to me
I ask for and receive as I have asked.

Truth and Reality

Truth can only be experienced.
It cannot be described
and it cannot be explained.

Truth is beyond your ability to destroy,
but entirely within your ability to accept.

Do not try to look beyond yourself for truth,
for truth can only be within you.

Truth lies only in the present,
and you will find it if you seek it there.

Truth is restored to you through your desire,
as it was lost to you through your desire
for something else.

How can a fact be fearful
unless it disagrees
with what you hold more dear than truth?

The search for truth is but the honest searching out
of everything that interferes with truth.
Truth *is*.
It can neither be lost nor sought nor found.
It is there, wherever you are, being within you.
Yet it can be recognized or unrecognized.

You cannot be safe *from* truth,
but only *in* truth.
Reality is the only safety.

Merely by being what it is,
does truth release you
from everything that it is not.

Reality cannot "threaten" anything except illusions,
since reality can only uphold truth.

Nothing real can be threatened.
Nothing unreal exists.
Herein lies the peace of God.

When a situation has been dedicated
wholly to truth,
peace is inevitable.

I am in need of nothing but the truth.

2
THE MIND

Mind
Belief
Thought
Perception

There is no limit on your learning
because there is no limit on your mind.

The source of all our experience is the mind. The true nature of the mind, says the Course, *is limitless transcendent awareness and creative power. However, our mistaken thoughts and beliefs, which direct the mind's activity, have distorted and constricted it. Consequently we must change our thoughts and beliefs in order to correct our perception and to restore the mind to its full potential.*

Mind

Every mind contains all minds,
for every mind is one.

Whatever you accept into your mind
has reality for you.
It is your acceptance of it
that makes it real.

Release your mind,
and you will look upon a world released.

If a mind perceives without love,
it perceives an empty shell
and is unaware of the spirit within.

Minds are joined;
bodies are not.
Only by assigning to the mind
the properties of the body
does separation seem to be possible.
And it is mind that seems to be
fragmented and private and alone.

The body is a limit
imposed on the universal communication
that is an eternal property of mind.
But the communication is internal.
Mind reaches to itself.
It does not go out.
Within itself it has no limits,
and there is nothing outside it.
It encompasses you entirely;
you within it and it within you.

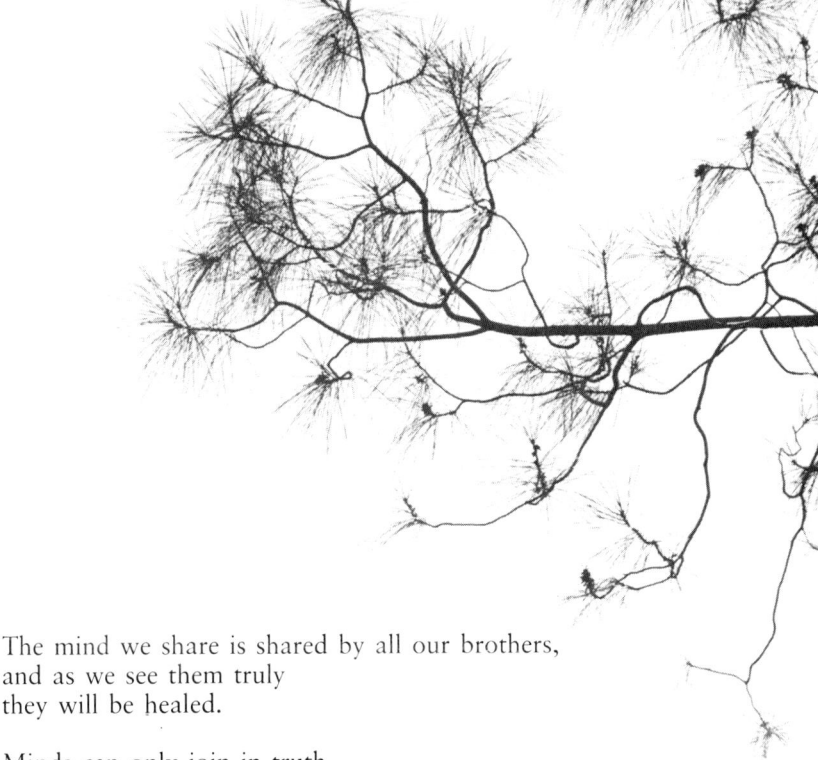

The mind we share is shared by all our brothers,
and as we see them truly
they will be healed.

Minds can only join in truth.
In dreams, no two can share the same intent.

The wakened mind is one that knows
its Source, its Self, its Holiness.

The mind that serves the Holy Spirit
is unlimited forever,
in all ways,
beyond the laws of time and space,
unbound by any preconceptions,
and with strength and power to do
whatever it is asked.

I rule my mind, which I alone must rule.
I have a kingdom I must rule.
At times, it does not seem I am its king at all.
It seems to triumph over me,
and tell me what to think,
and what to do and feel.
And yet it has been given me to serve
whatever purpose I perceive in it.
My mind can only serve.
Today I give its service to the Holy Spirit
to employ as He sees fit.
I thus direct my mind,
which I alone can rule.
And thus I set it free
to do the Will of God.

Belief

Your state of mind
and your recognition of what is in it
depend on what you believe about your mind.
Whatever these beliefs may be,
they are the premises that will determine
what you accept into your mind.

When you believe something,
you have made it true for you.

No belief is neutral.
Every one has the power to dictate
each decision you make.
For a decision is a conclusion
based on everything that you believe.

The recognition that you do not understand
is a prerequisite
for undoing your false ideas.

Truth will correct all errors in my mind.

Thought

There is no more self-contradictory concept
than that of "idle thoughts."
What gives rise to the perception of a whole world
can hardly be called idle.
Every thought you have
contributes to truth or to illusion;
either it extends the truth
or it multiplies illusions.

Every thought you have
makes up some segment
of the world you see.
It is with your thoughts, then,
that we must work,
if your perception of the world
is to be changed.

Nothing but your own thoughts
can hamper your progress.

Your ability to direct your thinking as you choose
is part of its power.
If you do not believe you can do this
you have denied the power of your thought,
and thus rendered it powerless in your belief.

You may believe that you are responsible
for what you do,
but not for what you think.
The truth is that you are responsible
for what you think,
because it is only at this level that
you can exercise choice.
What you do comes from what you think.

I am affected only by my thoughts.

Perception

Misperceptions produce fear
and true perceptions foster love.

You respond to what you perceive,
and as you perceive
so shall you behave.

Everything you perceive is a witness
to the thought system you want to be true.

What you perceive in others
you are strengthening in yourself.

Perception is a choice and not a fact.
But on this choice depends far more
than you may realize as yet.
For on the voice you choose to hear,
and on the sights you choose to see,
depends entirely your whole belief in what you are.

Instruction in perception is your great need.

What would you see?
The choice is given you.
But learn and do not let your mind
forget this law of seeing:
You will look upon that which you feel within.
If hatred finds a place within your heart,
you will perceive a fearful world,
held cruelly in death's sharp-pointed, bony fingers.
If you feel the Love of God within you,
you will look out on a world of mercy and of love.

Learn how to look on all things
with love, appreciation, and open-mindedness.

You have no conception of the limits
you have placed on your perception,
and no idea of all the loveliness that you could see.

Perception can make whatever picture
the mind desires to see.
Remember this.
In this lies either Heaven or hell,
as you elect.

Perception is a mirror, not a fact.
And what I look on is my state of mind,
reflected outward.

3
DREAMS AND ILLUSIONS

Dreams
Illusions

Your sleeping and your waking dreams
have different forms, and that is all.

*From our sleeping dreams we learn that our minds have
the ability to create worlds that, while we remain asleep,
seem completely real and appear to be outside us. Yet all
the people and things in these dreams are actually
creations of our own minds that we mistook for objective
reality. Only when we awaken do we recognize that none
of the events that seemed to happen in the dream ever
occurred.*

Like the deepest teachings of the great religions, the
Course *emphasizes that what we call "reality" is also a
dream—a dream from which we have not yet awakened
and hence do not recognize. The aim of the* Course *is to
help us recognize our dreams and illusions and to awaken
from them.*

Dreams

Dreams show you that you have the power
to make a world as you would have it be,
and that because you want it you see it.
And while you see it you do not doubt that it is real.
Yet here is a world, clearly within your mind,
that seems to be outside.

What you seem to waken to is but another form
of this same world you see in dreams.
All your time is spent in dreaming.
Your sleeping and your waking dreams
have different forms, and that is all.

In dreams effect and cause are interchanged,
for here the maker of the dream
believes that what he made
is happening to him.

The miracle establishes you dream a dream,
and that its content is not true.
This is a crucial step in dealing with illusions.
No one is afraid of them
when he perceives he made them up.
The fear was held in place because he did not see
that he was author of the dream,
and not a figure in the dream.

The first change,
before dreams disappear,
is that your dreams of fear
are changed to happy dreams.

Forgiving dreams are kind
to everyone who figures in the dream.
And so they bring the dreamer full release
from dreams of fear.

Do not forget that your will has power
over all fantasies and dreams.
Trust it to see you through,
and carry you beyond them .all.

Let not some dreams be more acceptable,
reserving shame and secrecy for others.
They are one. And being one,
one question should be asked of all of them,
"Is this what I would have,
in place of Heaven and the peace of God?"
This is the choice you make.
Be not deceived that it is otherwise.
No compromise is possible in this.
You choose God's peace,
or you have asked for dreams.

To mean you want the peace of God
is to renounce all dreams.
For no one means these words who wants illusions,
and who therefore seeks the means which bring illusions.
He has looked on them, and found them wanting.
Now he seeks to go beyond them,
recognizing that another dream would offer
nothing more than all the others.

The end of dreaming is the end of fear.

Now I see that I need only truth.
In that all needs are satisfied,
all cravings end,
all hopes are finally fulfilled
and dreams are gone.

Illusions

Every fantasy,
be it of love or hate,
deprives you of knowledge
for fantasies are the veil
behind which truth is hidden.
To life the veil that seems so dark and heavy,
it is only needful to value truth beyond all fantasy,
and to be entirely unwilling to settle for illusion
in place of truth.

Every illusion carries pain and suffering
in the dark folds of the heavy garments
in which it hides its nothingness.

Freedom from illusions lies
only in not believing them.

What is temptation
but a wish to make illusions real?

One illusion cherished
and defended against the truth
makes all truth meaningless,
and all illusions real.
Such is the power of belief.

Truth does not fight against illusions,
nor do illusions fight against the truth.
Illusions battle only with themselves.

You cannot perpetuate an illusion about another
without perpetuating it about yourself.

Without illusions
there could be no fear,
no doubt
and no attack.

Illusion recognized must disappear.

The father of illusions is the belief
that they have a purpose;
that they serve a need or gratify a want.
Perceived as purposeless,
they are no longer seen.

What is there to be saved from
except illusions?

Reality brings only perfect peace.
When I am upset,
it is always because I have replaced reality
with illusions I made up.

4
THE WORLD AND TIME

The World
Time

The only aspect of time
that is eternal is *now*.

The Course *suggests that the world and time are creations of mind and part of our dreams. When we forget this we lose awareness of our true identity and see ourselves as limited to bodies in the temporal world. Yet we are free to seek beyond the world and time for the eternal and the changeless—already present, as the* Course *emphasizes, in this and every moment.*

The World

Projection makes perception.
The world you see is what you gave it,
nothing more than that.
But though it is no more than that,
it is not less.
Therefore, to you it is important.
It is the witness to your state of mind,
the outside picture of an inward condition.
As a man thinketh, so does he perceive.

The world but demonstrates an ancient truth;
you will believe that others do to you
exactly what you think you did to them.

The world cannot dictate the goal
for which you search,
unless you give it power to do so.

The world that seems to hold you prisoner
can be escaped by anyone
who does not hold it dear.

What keeps the world in chains but your beliefs?
And what can save the world except your Self?

No longer is the world our enemy,
for we have chosen that we be its Friend.

Forget not that the healing of God's Son
is all the world is for.

I am not a victim of the world I see.

Time

Time and eternity are both in your mind,
and will conflict until you perceive time
solely as a means to regain eternity.

Now is the closest approximation of eternity
that this world offers.
It is in the reality of "now,"
without past or future,
that the beginning of the appreciation
of eternity lies.
For only "now" is here.

Look lovingly upon the present,
for it holds the only things that are forever true.
All healing lies within it.

When you have learned to look on everyone
with no reference at all to the past,
either his or yours as you perceive it,
you will be able to learn from what you see *now*.

To be born again is to let the past go,
and look without condemnation upon the present.

The present is before time was,
and will be when time is no more.
In it are all things that are eternal,
and they are one.

Fear is not of the present,
but only of the past and future,
which do not exist.

Why wait for Heaven?
It is here today.
Time is the great illusion it is past
or in the future.

Here in the present is the world set free.
For as you let the past be lifted
and release the future from your ancient fears,
you find escape and give it to the world.

What time but now can truth be recognized?
The present is the only time there is.

The past is gone;
the future but imagined.
These concerns are but defenses
against present change.

Unless the past is over in my mind,
the real world must escape my sight.
For I am really looking nowhere;
seeing but what is not there.

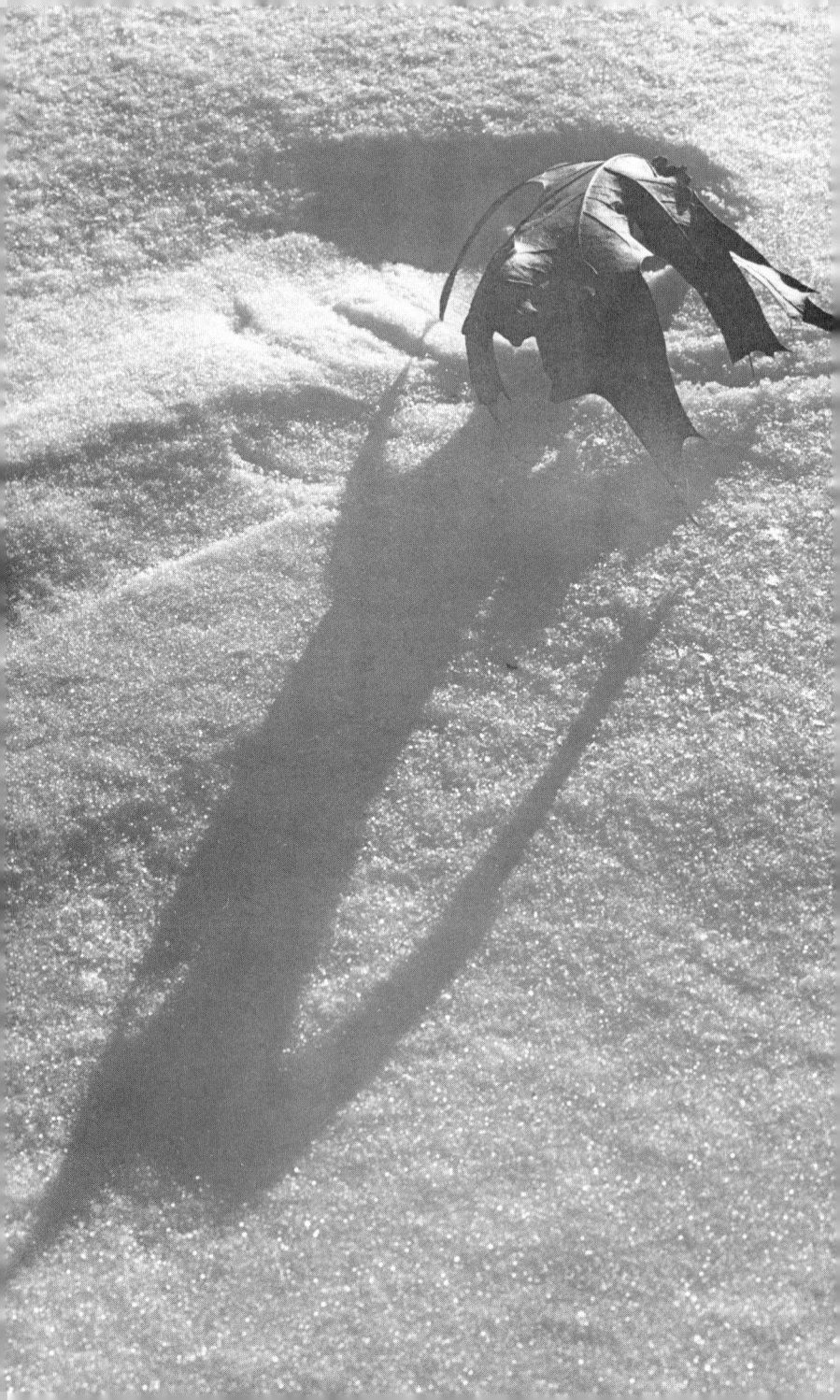

5
MISTAKEN IDENTITY

Body
Ego
Self-Concept

The ego is only an idea
and not a fact.

The Course *maintains that we have forgotten our true identities as creators of the dream, and constructed in its place a false self-concept, the ego. The ego sees itself as a victim of the world, confined to the body, alone and separated from others, the universe, and God. To awaken from the dream means recognizing the illusory nature of this constricted self-concept and perceiving the body, not as a means of grasping at the fleeting pleasures of the world or as a prison enclosing the Self, but as an instrument for learning and communication.*

Body

The body is a limit.
Who would seek for freedom in a body
looks for it where it cannot be found.

To accept the limits of a body
is to impose these limits
on each brother whom you see.
For you must see him as you see yourself.

The mind can be made free
when it no longer sees itself as in a body,
firmly tied to it and sheltered by its presence.

The body can but serve your purpose.
As you look on it,
so will it seem to be.

Temptation has one lesson it would teach,
in all its forms,
wherever it occurs.
It would persuade the holy Son of God he is a body,
born in what must die,
unable to escape its frailty,
and bound by what it orders him to feel.

The body is a fence
the Son of God imagines he has built,
to separate parts of his Self from other parts.

To see a body
as anything except a means of communication
is to limit your mind and to hurt yourself.

Sickness is anger taken out upon the body,
so that it will suffer pain.

Healing is the result
of using the body
solely for communication.

Forgiveness lets the body
be perceived as what it is:
a simple teaching aid,
to be laid by when learning is complete.

When the body ceases to attract you,
and when you place no value on it
as a means of getting anything,
then there will be no interference in communication
and your thoughts will be as free as God's.

Who transcends the body
has transcended limitation.

I am not a body,
I am free.
For I am still as God created me.

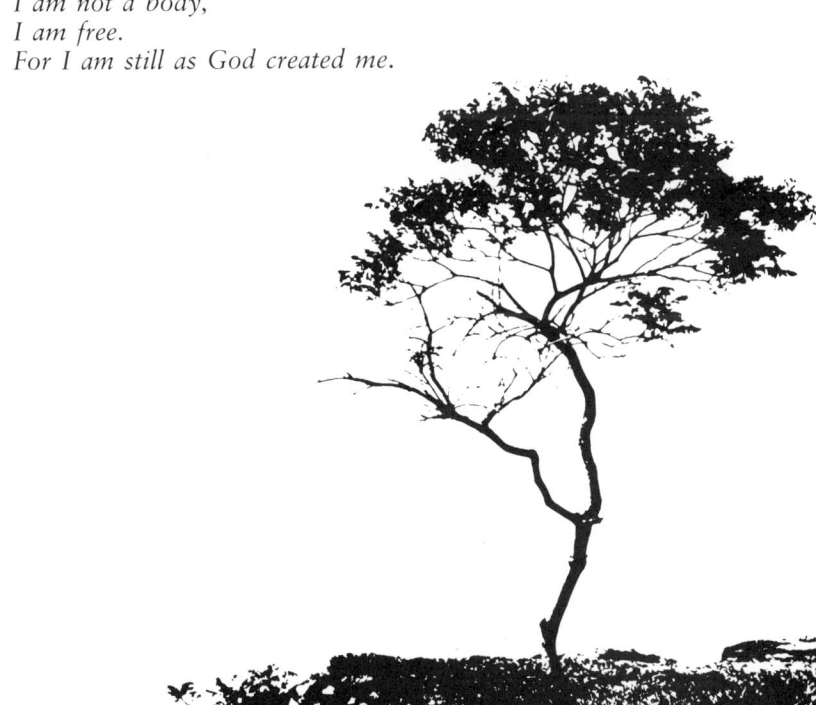

Ego

The ego is quite literally a fearful thought.

The ego is your belief.
The ego is a confusion in identification.

This fragment of your mind
is such a tiny part of it that,
could you but appreciate the whole,
you would see instantly
that it is like the smallest sunbeam to the sun,
or like the faintest ripple on the surface of the ocean.
In its amazing arrogance,
this tiny sunbeam has decided it is the sun;
this almost imperceptible ripple
hails itself as the ocean.
Think how alone and frightened is this little thought,
this infinitesimal illusion,
holding itself apart against the universe. . . .
Do not accept this little, fenced-off aspect as yourself.
The sun and ocean are as nothing beside what you are.

Do not be afraid of the ego.
It depends on your mind,
and as you made it by believing in it,
so you can dispel it
by withdrawing belief from it.

Only your allegiance to it
gives the ego any power over you.

The distractions of ego
may seem to interfere with your learning,
but the ego has no power to distract you
unless you give it the power to do so.

You must have noticed an outstanding characteristic
of every end that the ego has accepted as its own.
When you have achieved it,
It has not satisfied you.
That is why the ego is forced to shift ceaselessly
from one goal to another,
so that you will continue to hope
it can yet offer you something.

To hold a grievance
is to let the ego rule your mind.

No one alone can judge the ego truly.
Yet when two or more join together
in searching for truth,
the ego can no longer defend its lack of content.

Our union is therefore the way
to renounce the ego in you.
The truth in both of us
is beyond the ego.

You believe that without the ego,
all would be chaos.
Yet I assure you that without the ego,
all would be love.

If you will lay aside the ego's voice,
however loudly it may seem to call;
if you will not accept its petty gifts
that give you nothing that you really want;
if you will listen with an open mind,
that has not told you what salvation is;
then you will hear the mighty Voice of truth,
quiet in power, strong in stillness,
and completely certain in Its messages.

Self-Concept

What you think you are
is a belief to be undone.

The "self" that needs protection is not real.

Every response you make
is determined by what you think you are,
and what you want to be
is what you think you are.
What you want to be, then,
must determine every response you make.

All things you seek
to make your value greater in your sight
limit you further,
hide your worth from you,
and add another bar across the door
that leads to true awareness of your Self.

The concept of the self stands like a shield,
a silent barricade before the truth,
and hides it from your sight.
All things you see are images,
because you look on them as through a barrier
that dims your sight and warps your vision,
so that you behold nothing with clarity.

Your concept of the world depends upon
this concept of the self.
And both would go,
if either one were ever raised to doubt.

I will accept the truth of what I am,
and let my mind be wholly healed today.

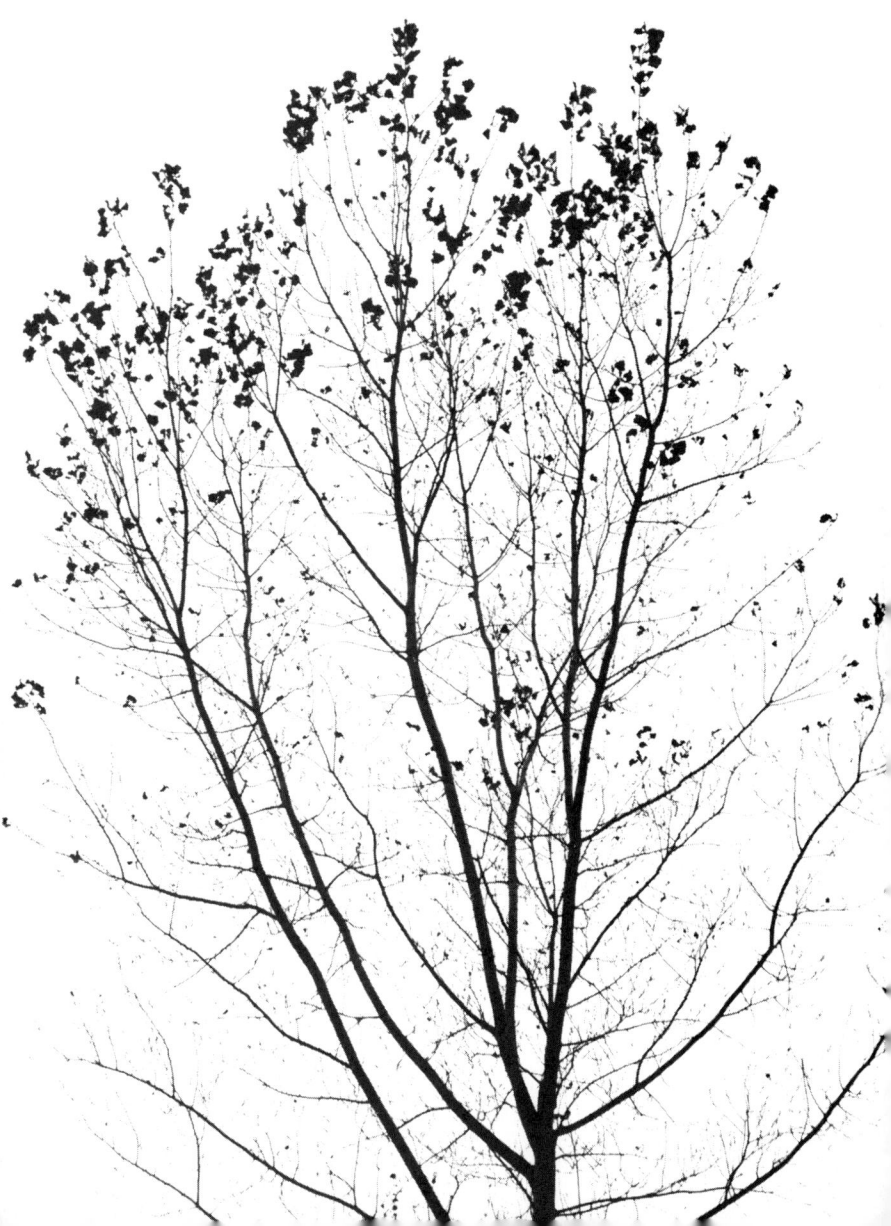

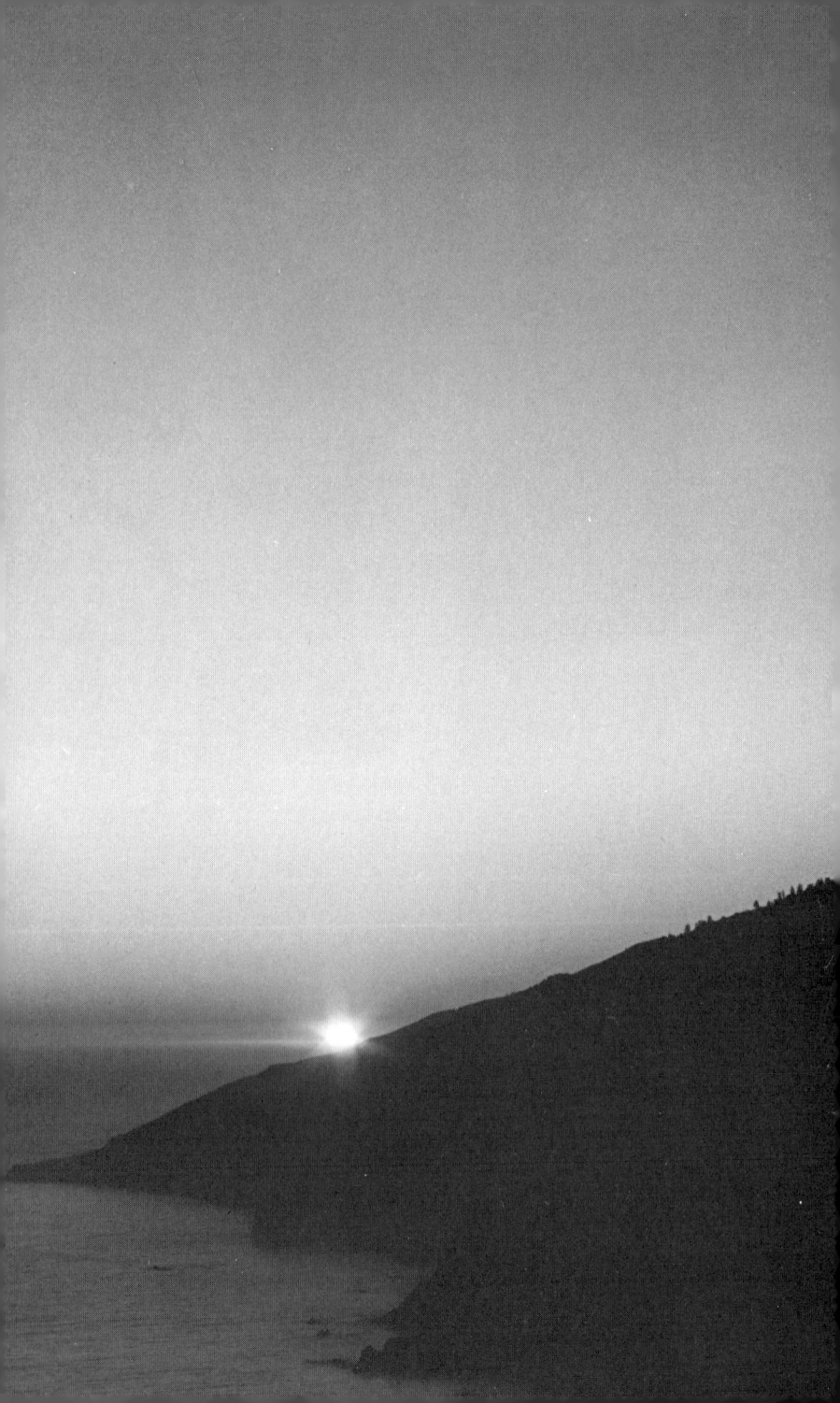

6
TRUE IDENTITY

Identity
Self
Spirit

What treasure would I seek and find and keep
that can compare with my Identity?

*To relinquish identification with the ego and the body is
to awaken to our true identity, says the* Course. *This true
identity has remained as it always was—pure spirit—for-
ever changeless, peaceful, and at one with God, awaiting
only our recognition.*

Identity

There is no conflict that does not entail
the single, simple question, "What am I?"

Every decision you make
stems from what you think you are,
and represents the value that you put upon yourself.

Only an illusion stands between you
and the holy Self you share.

You who perceive yourself as weak and frail,
with futile hopes and devastated dreams,
born but to die, to weep and suffer pain,
hear this:
All power is given unto you in earth and Heaven.
There is nothing that you cannot do.

You will identify with what you think
will make you safe.
Whatever it may be,
you will believe that it is one with you.
Your safety lies in truth,
and not in lies.
Love is your safety.
Fear does not exist.
Identify with love, and you are safe.
Identify with love, and you are home.
Identify with love, and find your Self.

*Let me not forget
myself is nothing,
but my Self is all.*

*I was created as the thing I seek.
I am the goal the world is searching for.*

Self

Nothing beyond yourself
can make you fearful or loving,
because nothing *is* beyond you.

Seek not outside yourself.
The search implies you are not whole within.

There is nothing outside you.
That is what you must ultimately learn.

Deep within you
is everything that is perfect,
ready to radiate through you
and out into the world.

In you is all of Heaven.

Nothing you do or think or wish or make
is necessary to establish your worth.

Light and joy and peace abide in you.

"I am as God created me."
This one thought would be enough
to save you and the world,
if you believed that it is true.

Let me remember I am one with God.
At one with all my brothers and my Self.

Spirit

Spirit is in a state of grace forever.
Your reality is only spirit.
Therefore you are in a state of grace forever.

Spirit makes use of mind
as means to find its Self-expression.
And the mind which serves the spirit
is at peace and filled with joy. . . .
Yet mind can also see itself
divorced from spirit,
and perceive itself within a body
it confuses with itself.
Without its function
then it has no peace,
and happiness is alien to its thoughts.

Your mind can be possessed by illusions,
but spirit is eternally free.

7
OBSTACLES ON THE PATH

Pain
Guilt
Fear
Anger and Attack
Judgment
Defensiveness

Fear condemns and love forgives.

If we are to escape "the bondage of illusions" and recognize our true identity, we must overcome the obstacles that keep us from awakening. Anger and attack, defensiveness and guilt, fear and judgment are among these. The Course *suggests that we create these obstacles out of false beliefs of unworthiness, inadequacy, and vulnerability. To relinquish them we must be willing to examine both obstacles and beliefs in the light of clear awareness, through which their illusory nature can be recognized. Only then can we experience the joy which is our natural condition.*

Pain

Pain is a sign
illusions reign
in place of truth.

Pain is a wrong perspective.
When it is experienced in any form,
it is a proof of self-deception.
It is not a fact at all.
There is no form it takes
that will not disappear if seen aright.

Nothing can hurt you
unless you give it the power to do so.

Pain is but the sign
you have misunderstood yourself.

Do you not see that all your misery
comes from the strange belief that you are powerless?

Seek not outside yourself. . . .
For all your pain comes simply from a futile search
for what you want,
insisting where it must be found.

Look about the world,
and see the suffering there.
Is not your heart willing
to bring your weary brothers rest?
They must await your own release.
They stay in chains till you are free.

Pain is the ransom
you have gladly paid
not to be free.

It is your thoughts alone
that cause you pain.
Nothing external to your mind
can hurt or injure you in any way.
There is no cause beyond yourself
that can reach down and bring oppression.
No one but yourself affects you.
There is nothing in the world
that has the power to make you ill or sad,
or weak or frail.
But it is you who have the power
to dominate all things you see
by merely recognizing what you are.

I can elect to change all thoughts that hurt.

Guilt

Love and guilt cannot coexist,
and to accept one is to deny the other.

While you feel guilty your ego is in command,
because only the ego can experience guilt.

Guilt is *always* disruptive.

Guilt is the result of attack.

The end of guilt will never come
as long as you believe there is a reason for it.
For you must learn that guilt is always totally insane,
and has no reason.

Release from guilt as you would be released.
There is no other way to look within
and see the light of love.

Guilt asks for punishment,
and its request is granted.
Not in truth,
but in the world of shadows and illusions.

The guiltless mind cannot suffer.

All salvation is escape from guilt.

Only my condemnation injures me.
Only my own forgiveness sets me free.

Fear

Fear is not justified in any form.

"There is nothing to fear."
This simply states a fact.
It is not a fact to those who believe in illusions,
but illusions are not facts.
In truth there is nothing to fear.

Fear lies not in reality,
but in the minds of children
who do not understand reality.

Only your mind can produce fear.

Attempting the mastery of fear is useless.
In fact, it asserts the power of fear
by the very assumption that it need be mastered.
The true resolution rests entirely
on mastery through love.

The need to recognize fear
and face it without disguise
is a crucial step in the undoing of the ego.

Fear itself is an appeal for help.
This is what recognizing fear really means.

Fear and attack are inevitably associated.
If only attack produces fear,
and if you see attack
as the call for help that it is,
the unreality of fear must dawn on you.
For fear *is* a call for love.

Look at what you are afraid of.
Only the anticipation will frighten you.

Under each cornerstone of fear
on which you have erected your insane system of belief,
the truth lies hidden.

Where fear has gone
there love must come,
because there are but these alternatives.
Where one appears, the other disappears.
And which you share becomes the only one you have.

Without anxiety the mind is wholly kind.

How deceived was I
to think that what I feared
was in the world,
instead of in my mind.

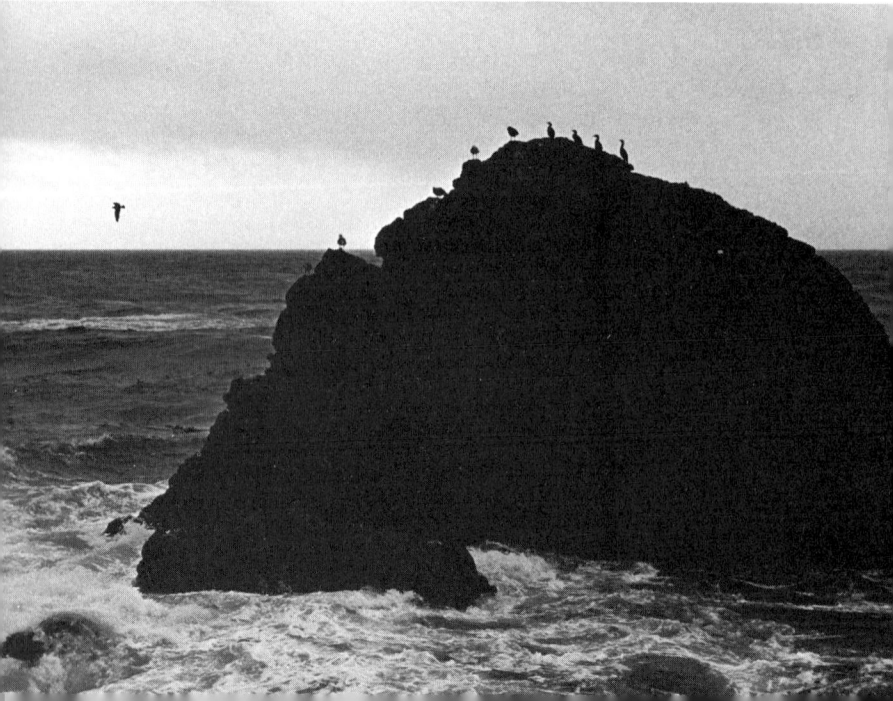

Anger and Attack

Every loving thought is true.
Everything else is an appeal for healing and help,
regardless of the form it takes.
Can anyone be justified in responding with anger
to a brother's plea for help?
No response can be appropriate
except the willingness to give it to him,
for this and only this is what he is asking for.

To the extent to which you value guilt,
to that extent will you perceive a world
in which attack is justified.
To the extent to which you recognize
that guilt is meaningless,
to that extent you will perceive
attack cannot be justified.

All anger is nothing more
than an attempt to make someone feel guilty.

Those who attack do not know they are blessed.
They attack because they believe they are deprived.
Give, therefore, of your abundance,
and teach your brothers theirs.
Do not share their illusions of scarcity,
or you will perceive yourself as lacking.

If you attack error in another,
you will hurt yourself.
You cannot know your brother
when you attack him.

You will fear what you attack.

Safety is the complete relinquishment of attack.

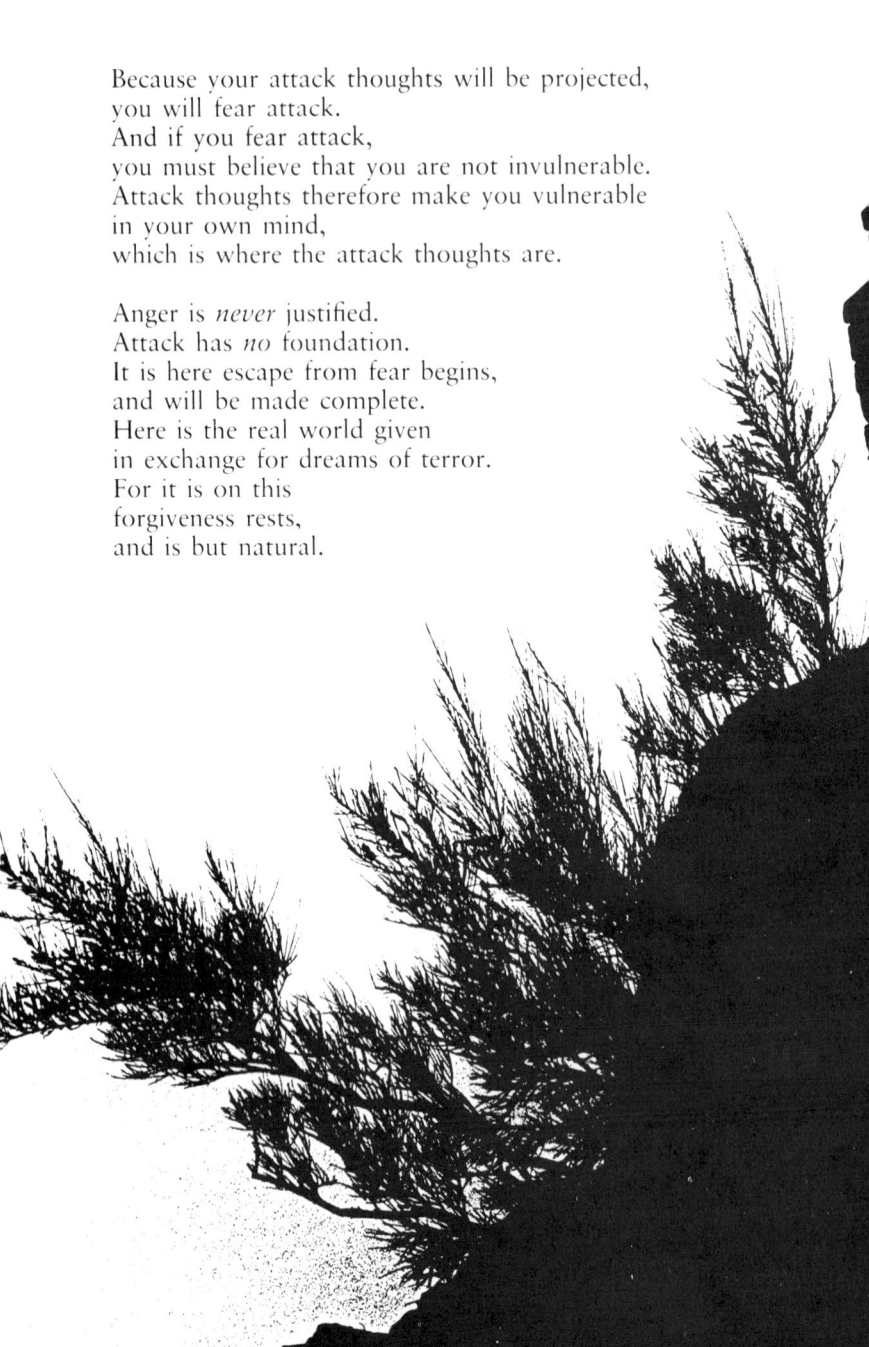

Because your attack thoughts will be projected,
you will fear attack.
And if you fear attack,
you must believe that you are not invulnerable.
Attack thoughts therefore make you vulnerable
in your own mind,
which is where the attack thoughts are.

Anger is *never* justified.
Attack has *no* foundation.
It is here escape from fear begins,
and will be made complete.
Here is the real world given
in exchange for dreams of terror.
For it is on this
forgiveness rests,
and is but natural.

Judgment

The choice to judge rather than to know
is the cause of the loss of peace.

You have no idea
of the tremendous release and deep peace
that comes from meeting yourself and your brothers
totally without judgment.

Judgment always imprisons
because it separates segments of reality
by the unstable scales of desire.

You who would judge reality
cannot see it,
for whenever judgment enters
reality has slipped away.

No one who loves can judge,
and what he sees is free of condemnation.

Comparison must be an ego device,
for love makes none.
Specialness always makes comparisons.
It is established by a lack seen in another,
and maintained by searching for,
and keeping clear in sight,
all lacks it can perceive.

Learn this, and learn it well,
for it is here delay of happiness is shortened
by a span of time you cannot realize.
You never hate your brother for his sins,
but only for your own.

Judgment was made to be a weapon
used against the truth.
It separates what it is being used against,
and sets it off as if it were a thing apart.
And then it makes of it
what you would have it be.
It judges what it cannot understand,
because it cannot see totality
and therefore judges falsely.

Wisdom is not judgment;
it is the relinquishment of judgment.

When I have forgiven myself
and remembered who I am,
I will bless everyone and everything I see.

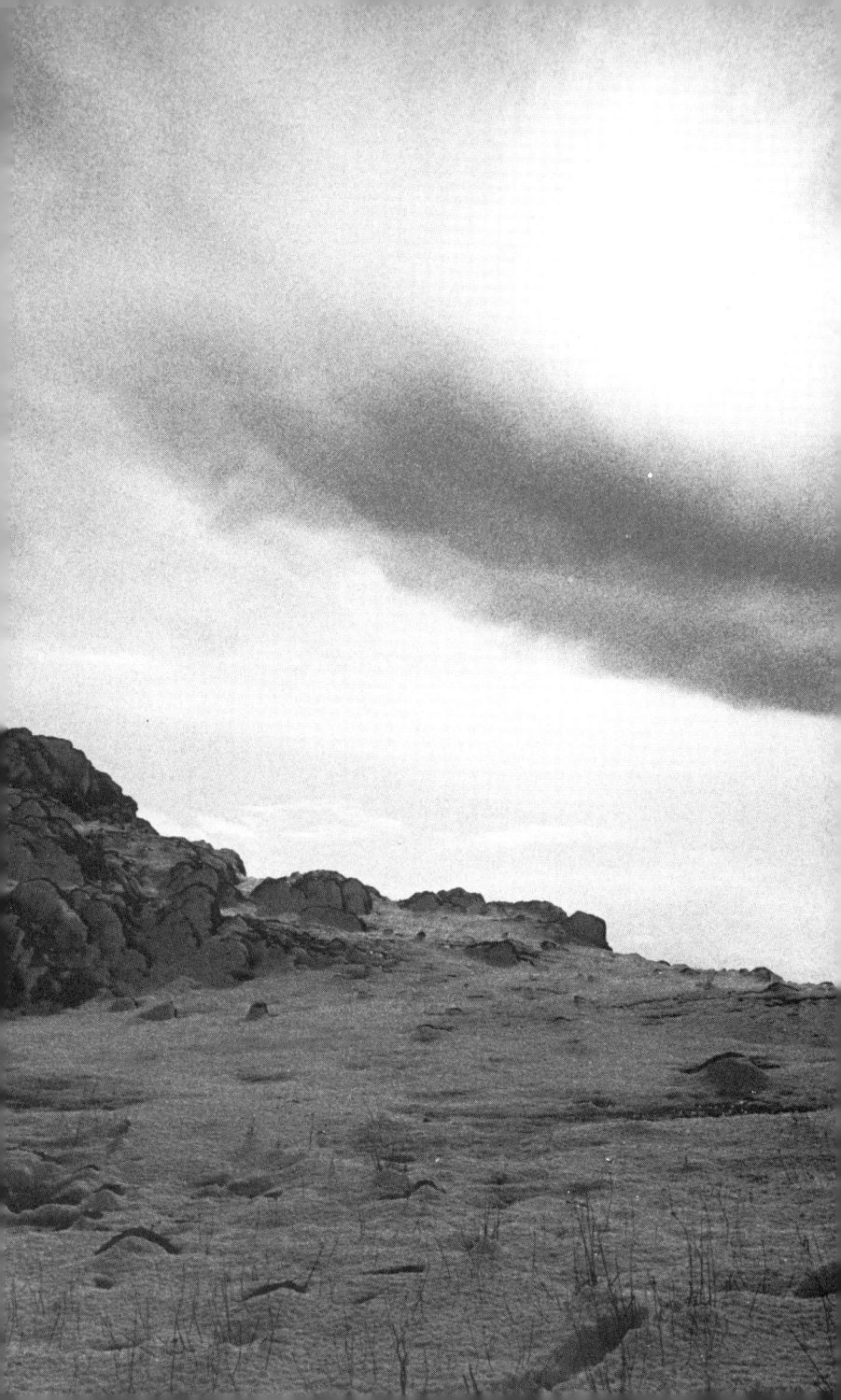

Defensiveness

When you feel the need arise
to be defensive about anything,
you have identified yourself with an illusion.

It is not danger that comes
when defenses are laid down.
It is safety. It is peace.
It is joy. And it is God.

No one walks the world in armature
but must have terror striking at his heart.

Defense is frightening.
It stems from fear,
increasing fear as each defense is made.
You think it offers safety.
Yet it speaks of fear made real and terror justified.

Defenses are but foolish guardians of mad illusions.

Defenselessness is all that is required
for the truth to dawn upon our minds with certainty.

Let no defenses
but your present trust
direct the future,
and this life becomes
a meaningful encounter with the truth.

Your defenses will not work,
but you are not in danger.
You have no need of them.
Recognize this,
and they will disappear.

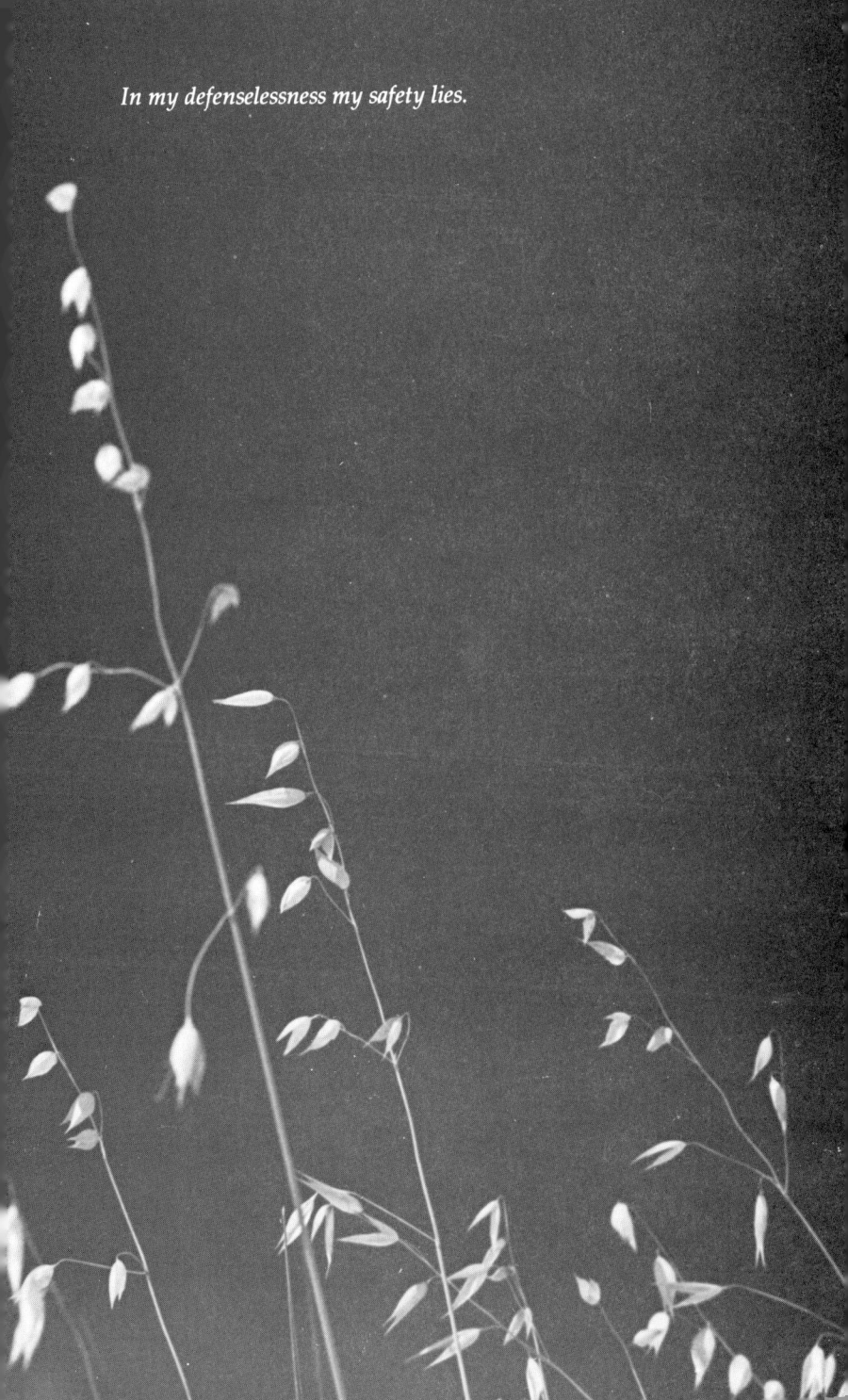

In my defenselessness my safety lies.

8
HEALING
RELATIONSHIPS

Practicing Forgiveness
Teaching and Learning
Recognizing Your Brother
Healing and Wholeness
The Holy Relationship

All healing involves replacing fear with love.

Relationships offer unique opportunities for learning, healing, and awakening. The Course *defines healing as "to make whole" and offers a variety of approaches by which relationships based on fear and deficiency can be transformed into holy relationships in which the obstacles to the awareness of love and wholeness are removed. It particularly emphasizes forgiveness of both ourselves and others as the means by which we can use relationships to let go of the past, with its burden of guilt and grievances, and to awaken to the present. Here we can establish true communication, experience love, recognize our true Self in each other, and join in this shared identity.*

Practicing Forgiveness

Ask not to be forgiven,
for this has already been accomplished.
Ask, rather, to learn how to forgive.

Forgive the world,
and you will understand
that everything that God created
cannot have an end,
and nothing He did not create is real.
In this one sentence is our course explained.

What could you want
forgiveness cannot give?
Do you want peace? Forgiveness offers it.
Do you want happiness, a quiet mind,
a certainty of purpose,
and a sense of worth and beauty
that transcends the world?
Do you want care and safety,
and the warmth of sure protection always?
Do you want a quietness that cannot be disturbed,
a gentleness that never can be hurt,
a deep, abiding comfort,
and a rest so perfect it can never be upset?
All this forgiveness offers you.

You who want peace
can find it only by complete forgiveness.

In complete forgiveness,
in which you recognize
that there is nothing to forgive,
you are absolved completely.

The real world is attained simply
by the complete forgiveness of the old.

Forgive the past and let it go, for it *is* gone.

Lift up your eyes
and look on one another in innocence
born of complete forgiveness of each other's illusions.

Those you do not forgive you fear.
And no one reaches love with fear beside him.

Forgiveness always rests upon the one who offers it.

Forgiveness takes away
what stands between your brother and yourself.
It is the wish that you be joined with him,
and not apart.

Forgiveness is the answer to attack of any kind.
So is attack deprived of its effects,
and hate is answered in the name of love.

Whom you forgive is given power
to forgive you your illusions.
By your gift of freedom is it given unto you.

As you give you will receive.

Giving and receiving are the same.

Illusions about yourself and the world are one.
That is why all forgiveness is a gift to yourself.

Forgiveness is the great need of this world,
but that is because it is a world of illusions.
Those who forgive
are thus releasing themselves from illusions,
while those who withhold forgiveness
are binding themselves to them.

He who would not forgive must judge,
for he must justify his failure to forgive.
But he who would forgive himself
must learn to welcome truth
exactly as it is.

Forgiveness is the key to happiness.
Here is the answer to your search for peace.
Here is the key to meaning
in a world that seems to make no sense.
Here is the way to safety in apparent dangers
that appear to threaten you at every turn,
and bring uncertainty to all your hopes
of ever finding quietness and peace.
Here are all questions answered;
here the end of all uncertainty ensured at last.

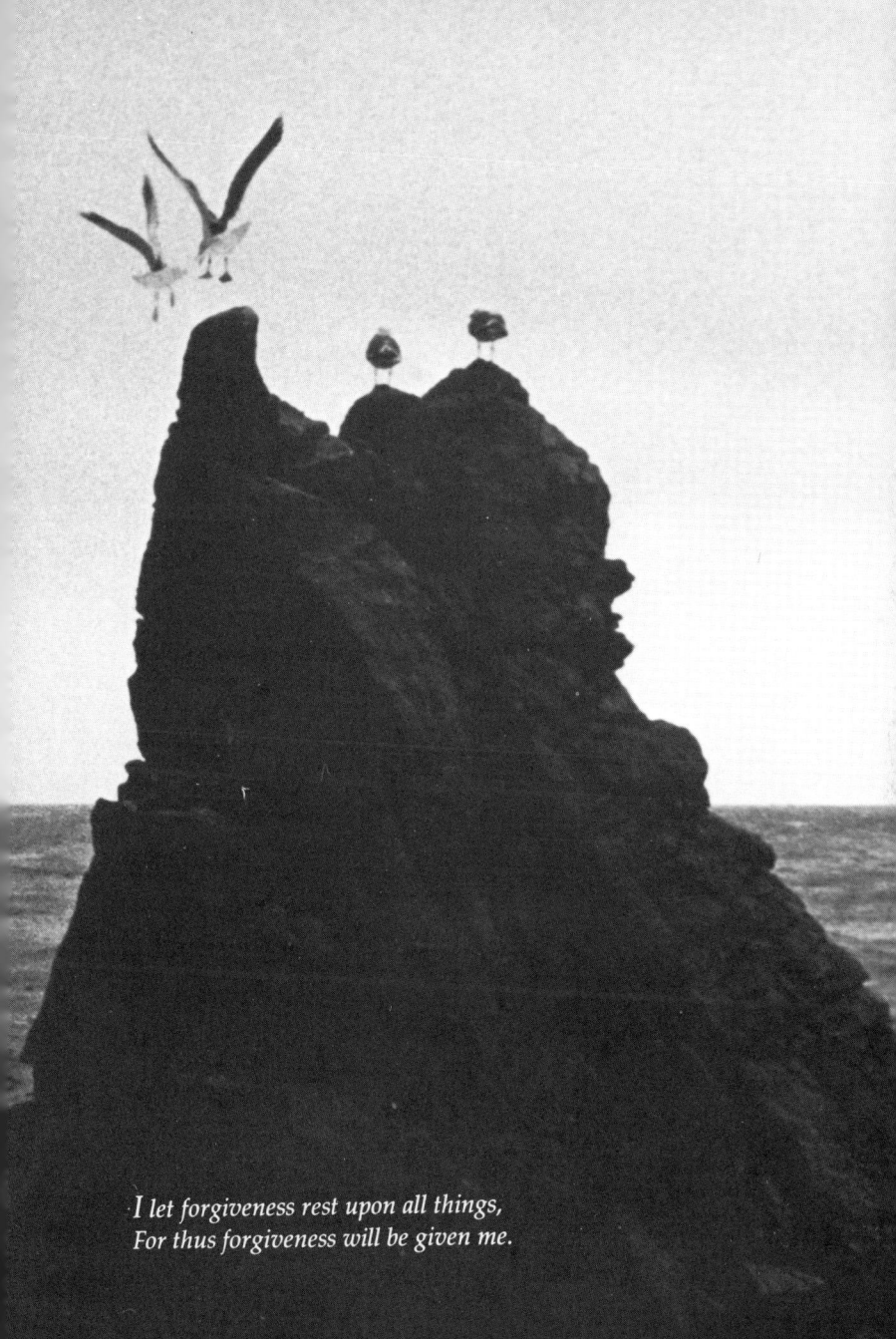

I let forgiveness rest upon all things,
For thus forgiveness will be given me.

Teaching and Learning

Listen silently
and learn the truth of what you really want.
No more than this will you be asked to learn.

There is no need to learn through pain.
And gentle lessons are acquired joyously,
and are remembered gladly.
What gives you happiness you want to learn
and not forget.

On your learning
depends the welfare of the world.

Everyone teaches,
and teaches all the time.
This is a responsibility you inevitably assume
the moment you accept any premise at all,
and no one can organize his life
without some thought system.
Once you have developed a thought system
of any kind,
you live by it and teach it.

The question is not whether you will teach,
for in that there is no choice.
The purpose of the course might be said
to provide you with a means of choosing
what you want to teach
on the basis of what you want to learn.

The course emphasizes that
to teach *is* to learn,
so that teacher and learner are the same.
It also emphasizes that teaching is a constant process.

Teaching and learning
are your greatest strengths now,
because they enable you to change your mind
and help others to change theirs.

Remember always that what you believe
you will teach.

"As you teach so will you learn."
If that is true, and it is true indeed,
do not forget that what you teach
is teaching you.

What you teach you strengthen in yourself
because you are sharing it.

You will not see the light,
until you offer it to all your brothers.
As they take it from your hands,
so will you recognize it as your own.

Any situation must be to you
a chance to teach others what you are,
and what they are to you.
No more than that, but also never less.

Teach no one that he is
what you would not want to be.
Your brother is the mirror
in which you see the image of yourself.

Everything you teach you are learning.
Teach only love, and learn that love is yours
and you are love.

Teach only love,
for that is what you are.

Recognizing Your Brother

When you meet anyone,
remember it is a holy encounter.
As you see him you will see yourself.
As you treat him you will treat yourself.
As you think of him you will think of yourself.
Never forget this,
for in him you will find yourself or lose yourself.

Everyone lives in you,
as you live in everyone.

Only appreciation is an appropriate response
to your brother.
Gratitude is due him for both his loving thoughts
and his appeals for help,
for both are capable of bringing love
into your awareness
if you perceive them truly.

Recognize all whom you see as brothers,
because only equals are at peace.

When you have seen your brothers as yourself
you will be released.

It will be given you to see your brother's worth
when all you want for him is peace.
And what you want for him
you will receive.

In truth you and your brother stand together,
with nothing in between.

Christ stands before you both,
each time you look upon your brother.

Dream of your brother's kindnesses
instead of dwelling in your dreams on his mistakes.
Select his thoughtfulness to dream about
instead of counting up the hurts he gave.
Forgive him his illusions, and give thanks to him
for all the helpfulness he gave.
And do not brush aside his many gifts
because he is not perfect in your dreams.

You can overlook your brother's dreams.
So perfectly can you forgive him his illusions
he becomes your savior from your dreams.

It is not up to you to change your brother,
but merely to accept him as he is.

You will never know that you are co-creator with God
until you learn that your brother
is co-creator with you.

Peace to my brother, who is one with me.
Let all the world be blessed with peace through us.

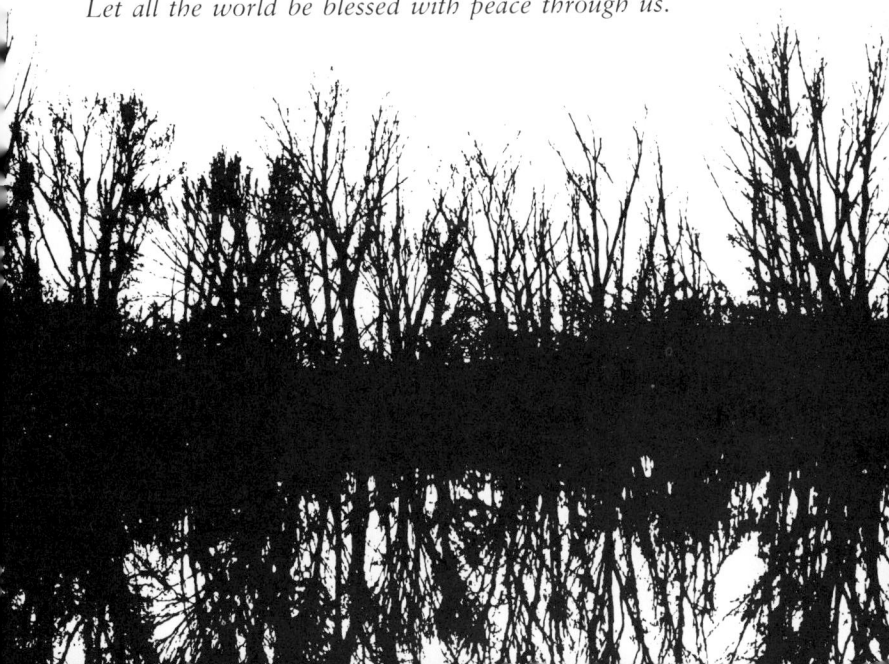

Healing and Wholeness

Every situation,
properly perceived,
becomes an opportunity to heal.

All healing is essentially the release from fear.

All healing is release from the past.

You heal a brother by recognizing his worth.

To love yourself is to heal yourself.

God cannot be remembered alone.
This is what you have forgotten.
To perceive the healing of your brother
as the healing of yourself
is thus the way to remember God.

Could you but realize for a single instant
the power of healing that the reflection of God,
shining in you,
can bring to all the world,
you could not wait
to make the mirror of your mind
clean to receive the image of
the holiness that heals the world.

We are made whole in our desire to make whole.

If you wish only to be healed, you heal.
Your single purpose makes this possible.

Healing is the effect of minds that join,
as sickness comes from minds that separate.

Those who are healed
become the instruments of healing.

To forgive is to heal.

Sickness is a defense against the truth.
I will accept the truth of what I am,
and let my mind be wholly healed today.

I am here only to be truly helpful
I am here to represent Him Who sent me.
I do not have to worry
about what to say or what to do,
because He Who sent me will direct me.
I am content to be wherever He wishes,
knowing He goes there with me.
I will be healed as I let Him teach me to heal.

The Holy Relationship

Those who have joined their brothers
have detached themselves from their belief
that their identity lies in the ego.
A holy relationship is one in which you join
with what is a part of you in truth.

An unholy relationship is based on differences,
where each one thinks
the other has what he has not. . . .
A holy relationship starts from a different premise.
Each one has looked within and seen no lack.
Accepting his completion, he would extend it
by joining with another, whole as himself.
He sees no difference between these selves,
for differences are only of the body.

You cannot know your own perfection
until you have honored
all those who were created like you.

When you have become willing to hide nothing,
you will not only be willing to enter into communion,
but will also understand peace and joy.

The Kingdom cannot be found alone,
and you who are the Kingdom
cannot find yourself alone.

There is no veil the Love of God
in us together cannot lift.

When you accepted truth
as the goal for your relationship,
you became a giver of peace.

No illusion can disturb the peace
of a relationship that has become the means of peace.

In your relationship is this world's light.

Alone we can do nothing,
but together our minds fuse into something
whose power is far beyond
the power of its separate parts.
By not being separate,
the Mind of God is established in ours and as ours.
This Mind is invincible because it is undivided.

You are one Self with me,
United with our Creator in this Self.
I honor you because of what I am,
And what He is, Who loves us both as one.

9
THE PEACEFUL ALTERNATIVE

Coming Home
Freedom
Salvation
Love
Awakening to God
The Conditions of Peace
Light and Joy

Peace is the state where love abides,
and seeks to share itself.

Only when the mind is at peace can it be freed of illusions and opened to the liberating influence of love, joy, and the memory of God that lie deep within us. In this experience we regain our sanity, Self, and salvation.

Coming Home

Would you not go through fear to love?
For such the journey seems to be.

It is a journey without distance
to a goal that has never changed.

You dwell not here,
but in eternity.
You travel but in dreams,
while safe at home.

There is no journey,
but only an awakening.

You are coming home together,
after a long and meaningless journey
that you undertook apart,
and that led nowhere.
You have found your brother,
and you will light each other's ways.

I will be still an instant and go home.

Freedom

It is essential that you free yourself quickly,
because you must emerge from the conflict
if you are to bring peace to other minds.

Hold no one prisoner.
Release instead of bind,
for thus are you made free.

You are not free to give up freedom,
but only to deny it.

As long as a single "slave" remains to walk the earth,
your release is not complete.

Be free today.
And carry freedom as your gift
to those who still believe
they are enslaved within a body.
Be you free,
so that the Holy Spirit
can make use of your escape from bondage,
to set free the many who perceive themselves
as bound and helpless and afraid.
Let love replace their fears through you.

I give you to the Holy Spirit as part of myself.
I know that you will be released, unless I want to
use you to imprison myself.
In the name of my freedom I choose your release.
Because I recognize that we will be released together.

Salvation

Changing concepts is salvation's task.

Be glad indeed salvation asks
so little, not so much.
It asks for nothing in reality.
And even in illusions it but asks
forgiveness be the substitute for fear.

Salvation is undoing.

Salvation can be seen
as nothing more
than the escape from concepts.

Those who would let illusions
be lifted from their minds
are this world's saviors.

Salvation comes from my one Self.

Love

Love will enter immediately
into any mind that truly wants it,
but it must want it truly.

Your task is not to seek for love,
but merely to seek and find
all of the barriers within yourself
that you have built against it.

Love waits on welcome,
not on time.

When you want only love
you will see nothing else.

If love is sharing,
how can you find it except through itself?
Offer it and it will come to you,
because it is drawn to itself.
But offer attack and love will remain hidden,
for it can live only in peace.

It is the nature of love to look upon only the truth,
for there it sees itself.

With love in you,
you have no need except to extend it.

You will not be able to give love welcome separately.
You could no more know God alone
than He knows you without your brother.
But together you could no more be unaware of love
than love could know you not,
or fail to recognize itself in you.

Grace is acceptance of the Love of God
within a world of seeming hate and fear.

Gratitude goes hand in hand with love,
and where one is the other must be found.

Love without trust is impossible.

Love would ask you
to lay down all defense
as merely foolish.

No course whose purpose is to teach
you to remember what you really are
could fail to emphasize that there can never be
a difference in what you really are and what love is.

If you achieve the faintest glimmering
of what love means today,
you have advanced in distance without measure
and in time beyond the count of years
to your release.

See the Love of God in you,
and you will see it everywhere
because it *is* everywhere.

Love, Which created me, is what I am.

Awakening to God

The memory of God can dawn only in a mind
that chooses to remember,
and that has relinquished the insane desire
to control reality.
You who cannot even control yourself
should hardly aspire to control the universe.

All that is needful is to train our minds
to overlook all little senseless aims,
and to remember that our goal is God.

The recognition of God
is the recognition of yourself.

God dwells within.

God's Will for you is perfect happiness.

The journey to God is merely the reawakening
of the knowledge of where you are always,
and what you are forever.

We practice but an ancient truth
we knew before illusion seemed to claim the world.
And we remind the world that it is free
of all illusions every time we say:
"God is but Love, and therefore so am I."

The Conditions of Peace

Peace is inevitable
to those who offer peace.

Peace is an attribute *in* you.
You cannot find it outside.

When the wish for peace is genuine,
the means for finding it is given
in a form each mind that seeks for it
in honesty can understand.
Whatever form the lesson takes is planned for him
in such a way that he cannot mistake it,
if his asking is sincere.
But if he asks without sincerity,
there is no form in which the lesson
will meet with acceptance
and be truly learned.

"I want the peace of God."
To say these words is nothing.
But to mean these words is everything.

The mind which means that all it wants is peace
must join with other minds,
for that is how peace is obtained.

The only way to have peace
is to teach peace.

Do you not think the world needs peace
as much as you do?
Do you not want to give it to the world
as much as you want to receive it?
For unless you do, you will not receive it.

When you have accepted your mission
to extend peace
you will find peace,
for by making it manifest you will see it.

Remember that you came
to bring the peace of God into the world.

If peace is the condition of truth and sanity,
and cannot be without them,
where peace is they must be.

The memory of God comes to the quiet mind.
It cannot come where there is conflict,
for a mind at war against itself
remembers not eternal gentleness.

When the light comes at last
into the mind given to contemplation;
or when the goal is finally achieved by anyone,
it always comes with just one happy realization:
"*I need do nothing.*"

Those who believe that peace can be defended,
and that attack is justified on its behalf,
cannot perceive it lies within them.

Those who offer peace to everyone
have found a home in Heaven
the world cannot destroy.
For it is large enough to hold the world
within its peace.

No one who truly seeks the peace of God
can fail to find it.
For he merely asks that he deceive himself no longer
by denying to himself what is God's Will.
Who can remain unsatisfied
who asks for what he has already?

The peace of God is shining in you now,
and in all living things.
In quietness is it acknowledged universally.

The peace of God is shining in me now.
Let all things shine upon me in that peace.
And let me bless them with the light in me.

Light and Joy

You are the light of the world.

The light is *in* you.
Darkness can cover it,
but cannot put it out.

Why wait for Heaven?
Those who seek the light
are merely covering their eyes.
The light is in them now.
Enlightenment is but a recognition,
not a change at all.

There is no difference
between love and joy.

Joy has no cost.
It is your sacred right.

You can exchange all suffering
for joy this very day.
Practice in earnest,
and the gift is yours.

Forgiveness is my function
as the light of the world.

My brother, peace and joy I offer you,
That I may have God's peace and joy as mine.

10
A NEW BEGINNING

There will come a time
when images have all gone by,
and you will see you know not what you are.
It is to this unsealed and open mind
that truth returns, unhindered and unbound.
Where concepts of the Self have been laid by
is truth revealed exactly as it is.

Let us be still an instant, and forget
all things we ever learned, all thoughts we had,
and every preconception that we hold
of what things mean and what their purpose is.
Let us remember not our own ideas
of what the world is for.
We do not know.
Let every image held of everyone
be loosened from our minds and swept away.
Be innocent of judgment,
unaware of any thoughts of evil or of good
that ever crossed your mind of anyone.
Now do you know him not.
But you are free to learn of him,
and learn of him anew.

Only be quiet.
You will need no rule but this,
to let your practicing today
lift you above the thinking of the world,
and free your vision from the body's eyes.
Only be still and listen.

Simply do this:
Be still, and lay aside all thoughts
of what you are and what God is;
all concepts you have learned about the world;
all images you hold about yourself.
Empty your mind of everything
it thinks is either true or false,
or good or bad,
of every thought it judges worthy,
and all the ideas of which it is ashamed.
Hold onto nothing.
Do not bring with you one thought
the past has taught, nor one belief
you ever learned before from anything.
Forget this world,
forget this course,
and come with wholly empty hands unto your God.

REFERENCES

To facilitate further study, we have referenced each passage included in this book, citing the volume and page number from which it was excerpted. WB stands for Workbook, T for Text, and MT for Manual for Teachers. A Course in Miracles *(three volumes, hardcover) may be ordered from Foundation for Inner Peace, P.O. Box 635, Tiburon, CA 94920 for $40.00. A single-volume paperback edition is available for $25.00. California residents add 6 percent sales tax.*

Dedication: WB 362

The Path of Light

WB 347. *The Nature of the* Course: WB 321; T 132; T 13; T 464; T Intro; WB 103. *Miracles:* T 1; T 203; T 1; T 549; T 390; WB 466. *Purpose:* T 341; MT 22; T 100; T 405; WB 341; WB 380. *Choice:* T 418; T 164; T 620; T 332; WB 352; T 418. *Truth and Reality:* T 139; T 74; T 152; T 234; T 412; T 429; T 267; T 150; T 271; T 149; T Intro; T 371; WB 410.

The Mind

T 131. *Mind:* WB 297; T 77; WB 238; T 9; T 359; T 360; T 113; WB 339; WB 312; WB 372; WB 400. *Belief:* T 124; T 116; T 464; WB 15; WB 189. *Thought:* WB 26; WB 34; WB 119; T 114; T 25; WB 461. *Perception:* T 35; T 7; T 192; T 73; T 425; T 196; WB 349; WB 45; T 301; MT 48; WB 441.

Dreams and Illusions

T 351. *Dreams:* T 351; T 351; T 473; T 552; T 351; T 579; WB 143; WB 340; WB 339; T 554; WB 410. *Illusions:* T 316; T 439; T 143; T 598; T 439; T 453; T 121; WB 189; WB 346; MT 35; WB 95; WB 83.

The World and Time

T 73. *The World:* T 415; T 545; WB 233; WB 226; WB 236; WB 361; T 476; WB 48. *Time:* T 168; T 230; T 234; T 233; T 234; T 234; T 281; WB 233; WB 236; WB 304; WB 329; WB 432.

Mistaken Identity

T 51. *Body:* WB 372; T 504; WB 372; T 389; T 619; WB 415; T 143; T 560; T 142; WB 355; T 301; MT 55; WB 378. *Ego:* T 77; T 121; T 364; T 121; T 61; T 128; T 144; WB 114; T 274; T 137; T 290; WB 187. *Self-Concept:* WB 155; WB 246; T 118; WB 227; T 617; T 612; WB 252.

True Identity

WB 431. *Identity:* WB 260; T 285; WB 445; WB 354; WB 415; WB 473; WB 449. *Self:* T 168; T 574; T 358; WB 63; T 490; T 49; WB 159; WB 195; WB 219. *Spirit:* T 7; WB 167; T 9.

Obstacles on the Path

WB 73. *Pain:* WB 351; WB 351; T 402; WB 179; T 430; T 573; WB 354; WB 352; WB 351; WB 429. *Guilt:* T 221; T 57; T 77; T 223; T 246; T 247; T 515; T 78; T 258; WB 370. *Fear:* WB 402; WB 77; T 198; T 26; T 28; T 202; T 202; T 202; T 204; T 267; T 558; T 92; WB 418. *Anger and Attack:* T 200; T 487; T 297; T 119; T 37; T 451; T 92; WB 40; T 593. *Judgment:* T 42; T 42; T 44; T 237; T 411; T 466; T 606; WB 446; MT 27; WB 83. *Defensiveness:* T 446; MT 13; WB 245; WB 245; MT 12; WB 248; WB 248; MT 39; WB 277.

Healing Relationships

T 147. *Practicing Forgiveness:* T 260; MT 50; WB 213; T 11; T 298; T 329; T 513; T 393; T 393; T 509; T 516; T 518; T 568; WB 213; T 504; WB 103; WB 73; WB 391; WB 210; WB 464. *Teaching and Learning:* T 605; T 416; T 449; T 84; MT 1; MT 1; T 48; T 86; T 92; T 92; WB 278; MT 1; T 118; T 92; T 92. *Recognizing Your Brother:* T 132; T 193; T 201; T 108; T 242; T 405; T 446; T 491; T 543; T 568; T 156; T 163; WB 474. *Healing and Wholeness:* T 371; T 19; T 240; T 127; T 198; T 203; T 271; T 354; T 535; T 553; WB 255; MT 53; WB 252; T 24. *The Holy Relationship:* T 424; T 435; T 119; T 8; T 132; T 317; T 346; T 448; T 353; T 136; WB 166.

The Peaceful Alternative

T 455. *Coming Home:* T 316; T 139; T 240; T 222; T 354; WB 331. *Freedom:* T 30; WB 356; T 174; T 13; WB 373; T 306. *Salvation:* T 616; T 590; T 614; T 613; T 445; WB 168. *Love:* T 55; T 315; T 238; T 215; T 217; T 382; T 292; T 366; WB 315; WB 363; MT 21; WB 318; WB 225; WB 226; T 120; WB 396. *Awakening to*

God: T 218; WB 413; T 136; T 574; WB 177; T 139; WB 322. *The Conditions of Peace:* MT 28; T 15; WB 340; WB 339; WB 339; T 92; T 134; T 216; WB 194; T 341; T 452; T 363; T 461; T 490; WB 340; WB 347; WB 348. *Light and Joy:* WB 102; T 352; WB 347; T 66; T 592; WB 305; WB 103; WB 186.

A New Beginning

T 613; T 602; WB 221; WB 350.

A tape of readings from *Accept This Gift* by Frances Vaughan may be ordered from Miracle Distribution Center, 1141 East Ash Ave., Fullerton, CA 92631. Price is $9.00 plus $1.00 shipping and handling. California residents add 6 percent sales tax.